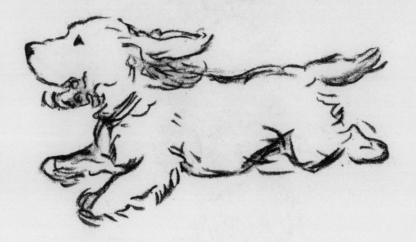

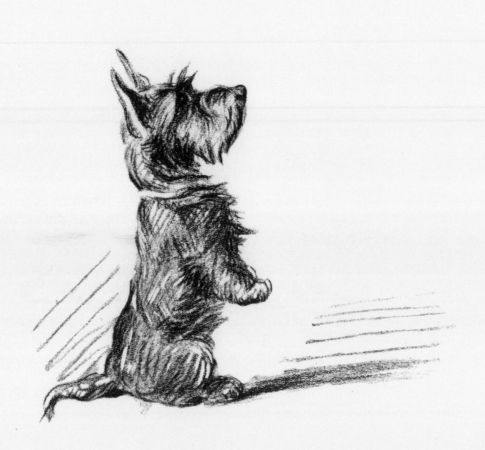

DOGS AS I SEE THEM

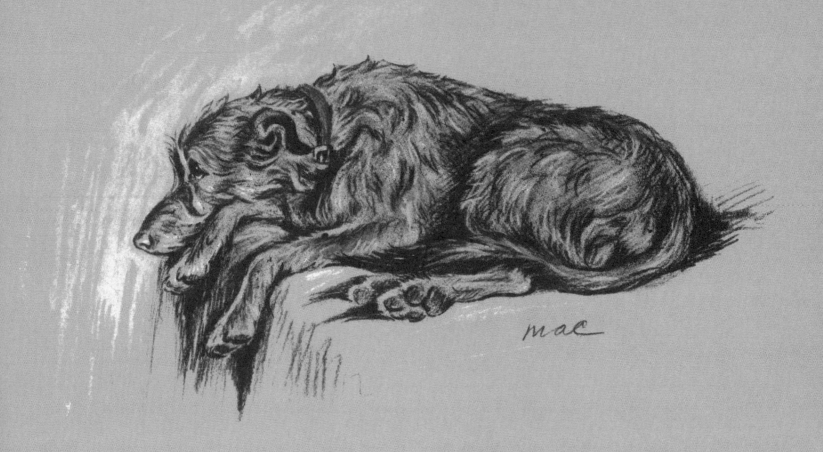

DOGS AS I SEE THEM

by

LUCY DAWSON

Mac

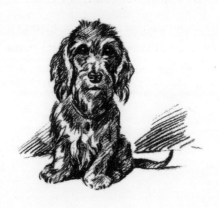

With 22 Illustrations in Color

FOREWORD BY ANN PATCHETT

HARPER
DESIGN

An Imprint of HarperCollinsPublishers

Dogs As I See Them

First published in 2015 by
Harper Design
An Imprint of HarperCollins*Publishers*
195 Broadway
New York, NY 10007
Tel: (212) 207-7000
Fax: (855) 746-6023
harperdesign@harpercollins.com
www.hc.com

Distributed throughout the world by
HarperCollins*Publishers*
195 Broadway
New York, NY 10007
Fax: (855) 746-6023

ISBN 978-0-06-241288-1

Library of Congress Control Number: 2014958915

Printed in Malaysia

First printing, 2015

DOGS AS I SEE THEM

Lucy Dawson's friendly, sympathetic portraits of dogs so delighted readers of numerous English and American periodicals that they finally were gathered together to make a book.

With her sketches are her own amusing notes about the conduct of the dogs while they posed. These charming little reminiscences interpret the character and mood of each and make us friends at once with every one in this gallery of engaging portraits.

The artist herself says that it is because dogs feel and portray to the full the emotions of love, hate, fear, trust, and humor that she loves them, both as friends and as models for her pictures.

In her own words: "An old dog dreaming before the fire, a dog in the perfection of its mature strength romping with a friend, either canine or human, a puppy sitting thinking of the puzzling wonderments of life—they make the dog lover in me thrill with happiness and the artist in me itch for my drawing materials."

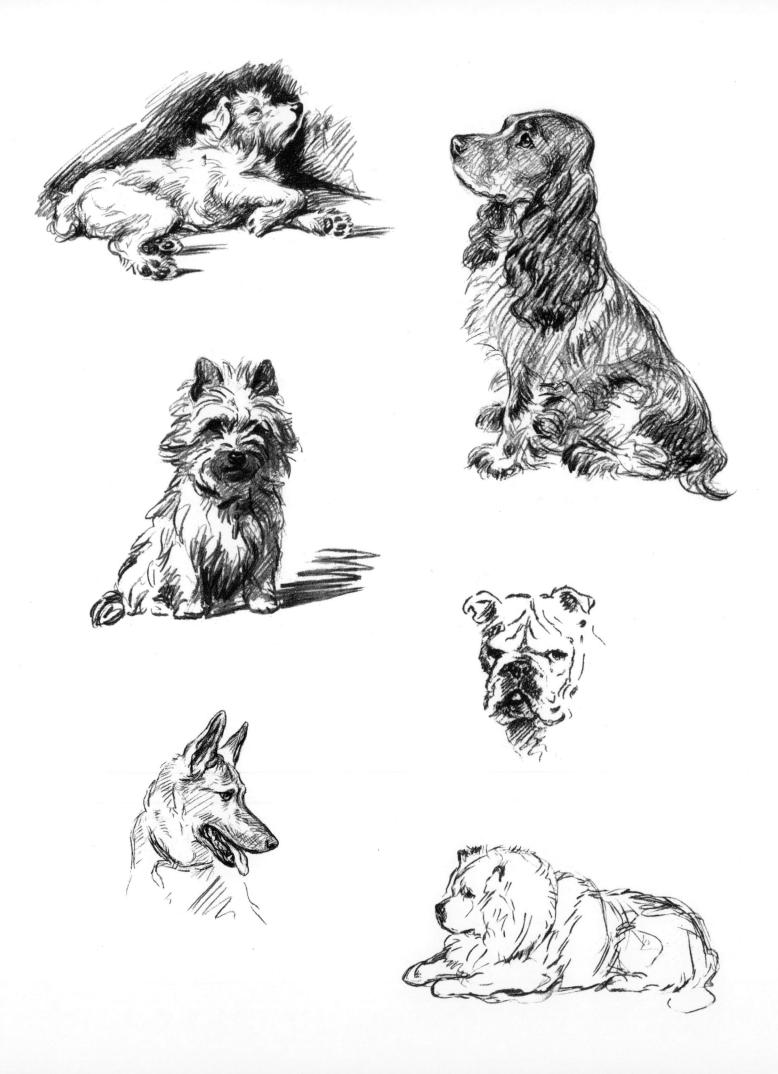

CONTENTS

FOREWORD

As I was settling down to work this morning, Scooter, our houseguest, found a good spot beside me on the sofa from which to embark on his first nap of the day. Scooter weighs six pounds and is gray and white. He has a tail like a cheerleader's prop and a left ear that stands up when he means to express interest. He's never been sufficiently interested in anything that I've seen to rally the energy of his right ear. He is less like a dog and more like some mysterious animal one might glimpse in the jungles of Papau, New Guinea, an animal about which one might say, "It almost looked like a *dog*!" He is capable of both great energy and great stillness, and that, along with the fact that he neither sheds nor barks, makes him excellent company. Scooter was invited for an extended visit because he is a friend of our dog, Sparky. Their friendship came about because Scooter and Sparky resemble one another. The first time the two dogs met and ran in tearing circles through my house, I couldn't tell where one left off and the other began. They made a blur of a single creature, something Odysseus might have encountered had he pressed on to one more island: an eight-legged, four-eared, two-tailed beast. Certainly their temperaments were similar. They are sweet-natured dogs, both quick to relinquish a toy or a bone to the other, both quick to roll themselves into small balls and squeeze into the space between my lower back and the sofa cushion—tiny, breathing lumbar supports.

Except now that Scooter has been with us awhile I can see that they're very different beings. Sparky outweighs his guest by nine pounds. He's younger, eats less, and walks slower. He isn't Scooter's match in jumping, but Sparky can sit up like a squirrel, perfectly balanced, for up to ten minutes at a time.

Because Sparky is my dog and I am his person, I tell myself that I know what he's thinking, whereas Scooter, dark-eyed and silent, is inscrutable.

We met Scooter because I own a bookstore. Scooter's owner, a magician named Ben Whiting, saw a picture of Sparky on our store's Web site and noted the very apparent similarities between our two dogs. Since Sparky came from the Humane Association of Nashville, and Scooter was found shivering in an alley behind a theater in Des Moines, both of us had wondered what these dogs, who looked like no one except each another, might be. Pictures were exchanged and soon a friendship ensued. When Ben and his wife, Erin, were planning to be out of the country for three weeks, I suggested that Scooter could stay with us.

I was explaining all of this to my neighbor Whitney and her four-year-old daughter, Wynn, when they came by for a visit. They wanted to know how I'd managed to find a dog who looked so much like Sparky. "Scooter's dad is a magician," I said to Wynn. "He performs magic every day on a cruise ship going to New Zealand. Scooter is staying with us while his dad is working."

Whitney looked at her daughter with great seriousness. "Remember that," she said. "That's one they'll never tell you about in school: You could grow up to be a magician performing on a cruise ship. You could go to New Zealand."

When I was growing up, people didn't tell little girls in Catholic school that they could write novels for a living, but I suppose it wasn't such a feat of reasoning that I figured it out. Novels had to be written by someone so it might as well have been me. Still, I didn't know that I could work as a magician on a cruise ship. As much as I may have contemplated the possibilities of my life, I never could have put that one together. I also never figured that drawing soulful portraits of dogs could be a means of gainful employment.

I've been very happy as a writer and would say that until this point I've never thought of anything I would have rather done with my life, but now that's changed: I would rather have made my living drawing dogs. I would rather people drop off a terrier in the morning, or a spaniel, or some unidentifiable mix, and let me spend the day considering the dog's particular virtues.

Of course, to make a living from drawing one would need to be as good as Lucy Dawson, and from what I've seen of dog portraiture, no one ever has been, not before her or since. The subjects of *Dogs As I See Them* (a book that has been shamefully out of print for more than fifty years and is hereby resurrected) are as timeless and relevant today as they were when Dawson drew them in England in the 1930s. Because while telephones have been improved and travel has been improved, dogs have not been improved. Dogs were perfect to begin with and so have been spared man's insistent impulse to modernize. Throughout the course of history, other artists, more famous artists, have done portraits of dogs, or dogs walked through the larger tableaus of their paintings, but it always seemed the artists' purpose for the dog was to render him meticulously or artfully rather than to bring him to life. The dogs of Albrecht Dürer seem to have been cobbled together from various pieces of dogs and lions and machinery. Those painted dogs never speak to me of all the things the living dog beside me on the sofa speaks of so clearly: energy, rest, loyalty, and compassion.

Lucy Dawson's genius—and I can't imagine how such a thing is done— is her ability to draw the personality of every dog she met. With no fanfare, no wallpaper or sofa cushions or forest backdrops to set the mood, she captured the central part of each dog's being—Creenagh and Joan and Bob—kind and shy, impatient and generous. Lucy Dawson, who often signed her drawings as Mac, saw the best in all of them. There is such a spareness in these works, as if every mark on the page was meant to show nothing more than who the dog was, and once that was established she

lifted her pencil and stopped. Of course the dogs themselves must have added a great deal of immediacy to the situation, because even the oldest and sleepiest of dogs isn't going to sit still forever. In the case of Binkie, the first dog in the book, you can see he was going to give her his time in seconds, not minutes. His desire to run after a ball all but vibrates on the page.

Every portrait comes with a bit of background information: who needed extra biscuits for incentive and who preferred to sleep on his back. These stories are given as gifts, as if Lucy Dawson knew that we would want to know more about a dog who was so lovely and present. We're given a few loose sketches as well, the dogs running and tumbling across the pages, just so we'll know that sitting still never happened for long. These three things together, the sketches, the narrative, and the formal portrait, form a fully dimensional life. How loved these dogs were! How proud their owners must have been to have a portrait to take away.

Art is the gift of immortality. I look through these pages at so many alert ears and shining eyes and think that all of these dogs are gone now, along with their puppies, and their puppies' puppies, far down the line. And then I think they're right here, all of them, thanks to Lucy Dawson's extraordinary talent and insight. She would have seen the differences between Sparky and Scooter in an instant. She would have drawn them standing beside one another or curled into a single ball. Anyone would have seen how separate and unique they are, not just their physical selves, but the distinct light that each dog makes.

Albert and George and Berbay's Lad, I'm so glad these dogs are back. I'm glad that Lucy Dawson is back. I hope that someone finds this book, maybe my neighbor Wynn, and thinks that drawing dogs might be the best way to make a living. Clearly, it was the best possible life for Lucy Dawson.

—ANN PATCHETT

BINKIE

Very, very young and quite unaccustomed to sitting on a table. Moreover, the table was slippery and only the kind attention of his owner kept him on it at all. But Binkie was fascinated with my scratchings on paper and couldn't think why he was such an object of interest.

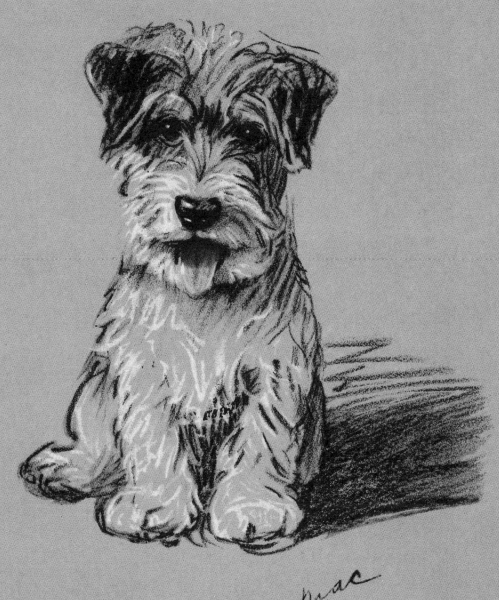

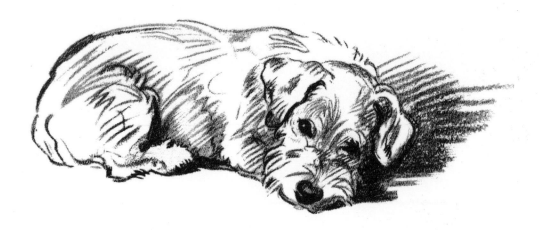

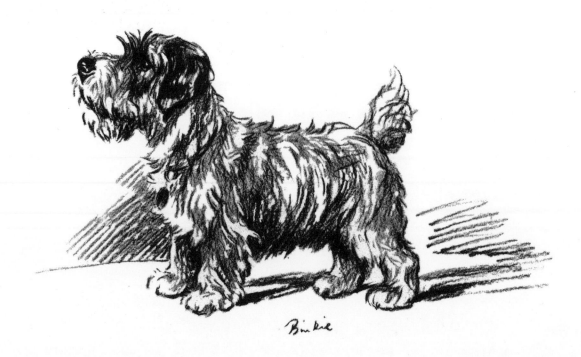

Binkie

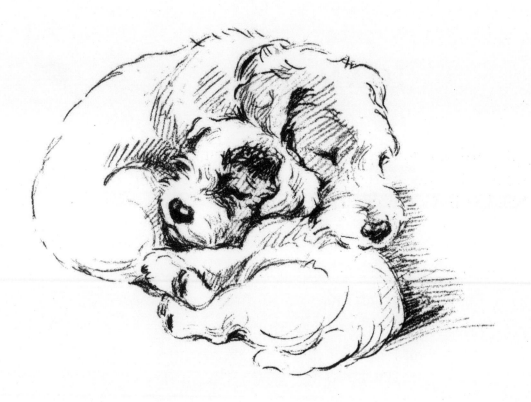

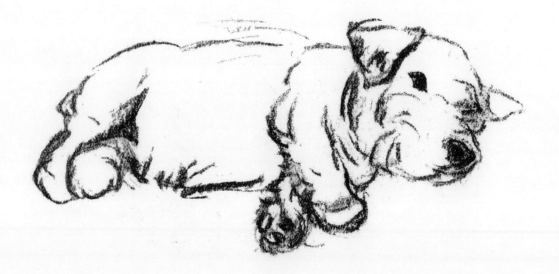

JOAN

A very shy little cairn, friend and companion of Ian, who is winner of many prizes. The lucky little dogs spend glorious holidays in Cornwall each year.

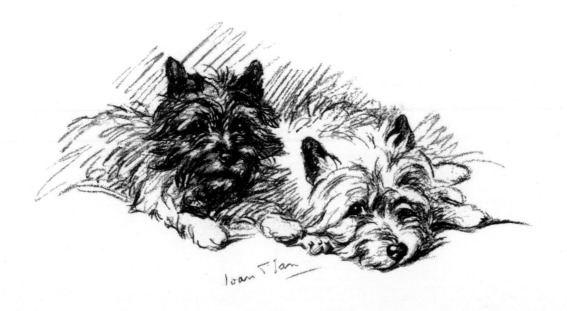

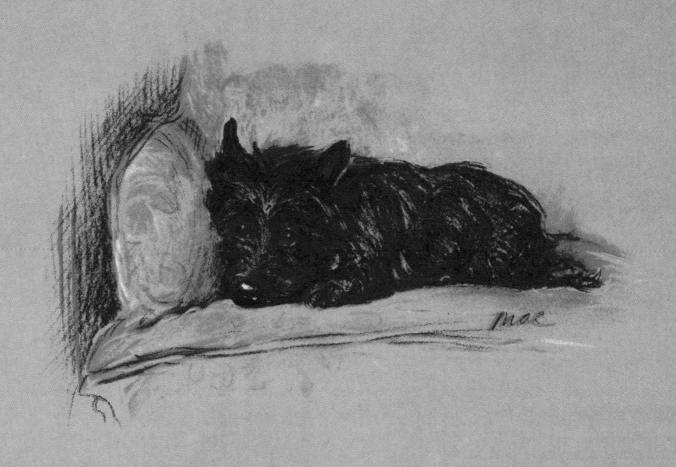

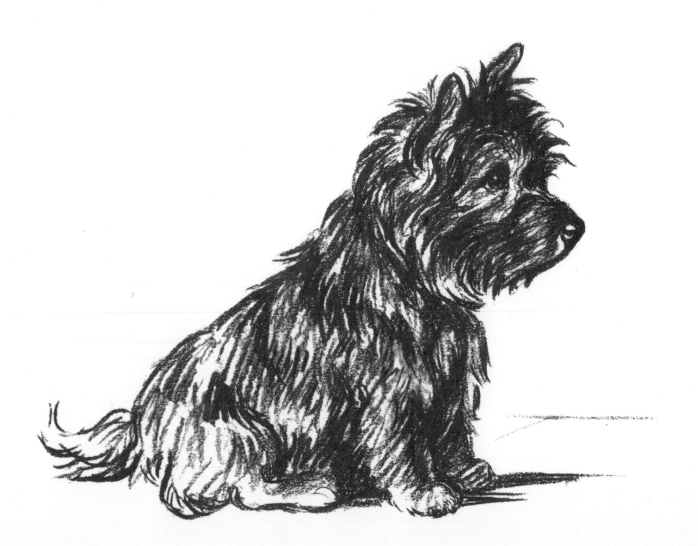

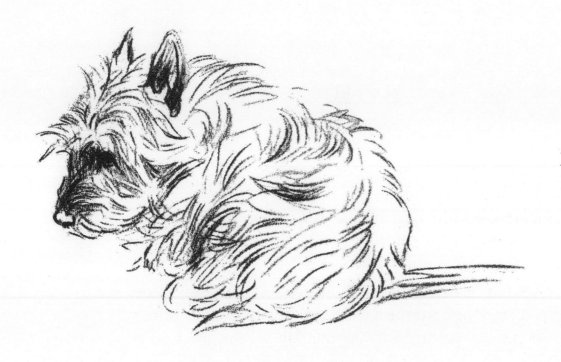

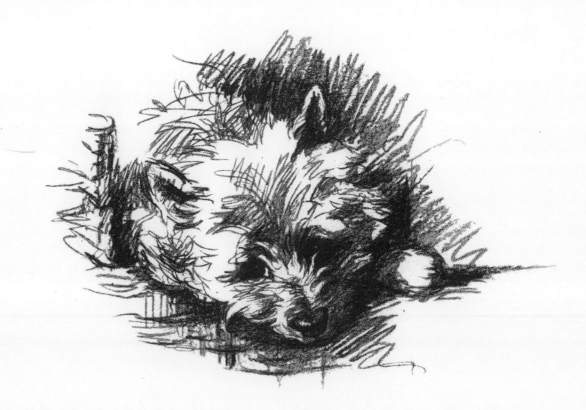

BOB

My constant companion for five years—a little stray who was found exhausted under a hedge when about eighteen months old. He always lay on the couch in my studio, "sleeping" with one eye open to see what I was up to and never forgetting to tell me when it was lunchtime.

I always remember, when spending a holiday at my little country cottage one summer, how Bob buried bones in the cornfield the day he arrived. On the day we returned poor Bob couldn't find his precious bones because the corn had been cut in the meantime so that he lost his bearings! We nearly lost our homeward bus as well. Dear old Bob!

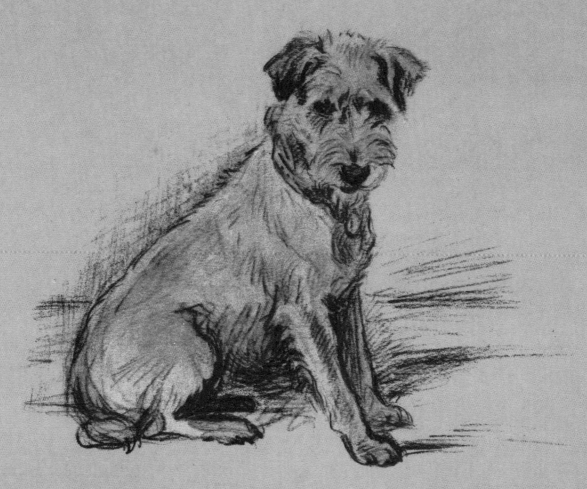

My Tailwagger Luc, Dawson

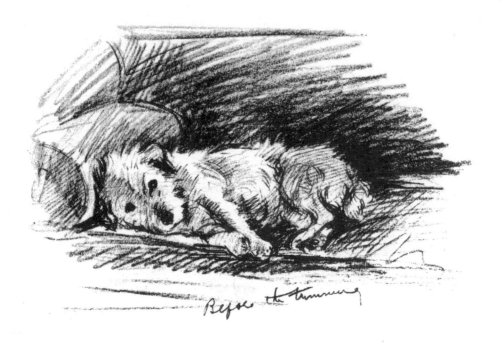

Before the trimming

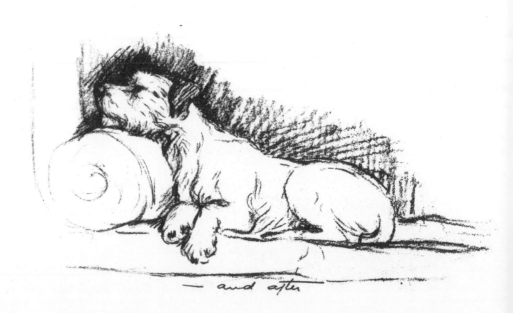

— and after

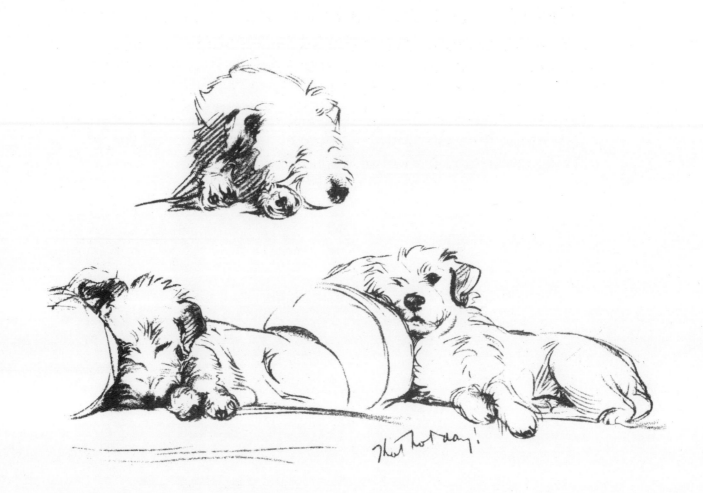

NANKI POO

I journeyed from London to a lovely bit of country in Northamptonshire in order to draw him, but that, of course, didn't impress Nanki Poo, who is accustomed to such attentions and only condescended to lie the right way up just long enough for me to make the colored sketch. I think you can judge from the other sketches how he behaved for the rest of the time. Anyhow, I suppose he must be excused for being rather "upsidedownish," as he is very beautiful.

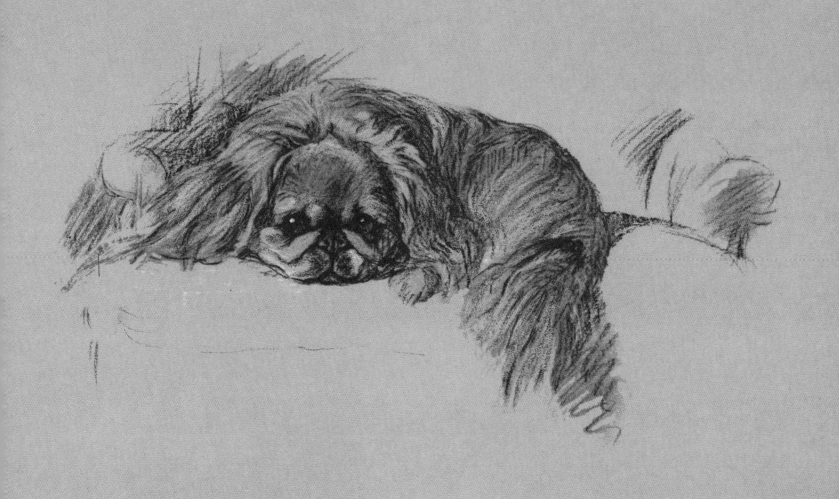

JANE

Jane's sole care is the baby son of her master and mistress. She keeps such a careful guard over him that I had the impression she thought I was not to be trusted. Jane lives a family life and, although a sporting dog, I don't think she worries much about it. But never mind, she is very healthy and happy and unspoiled—which is the main thing.

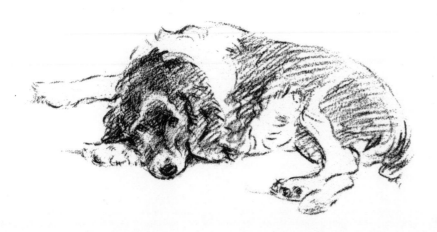

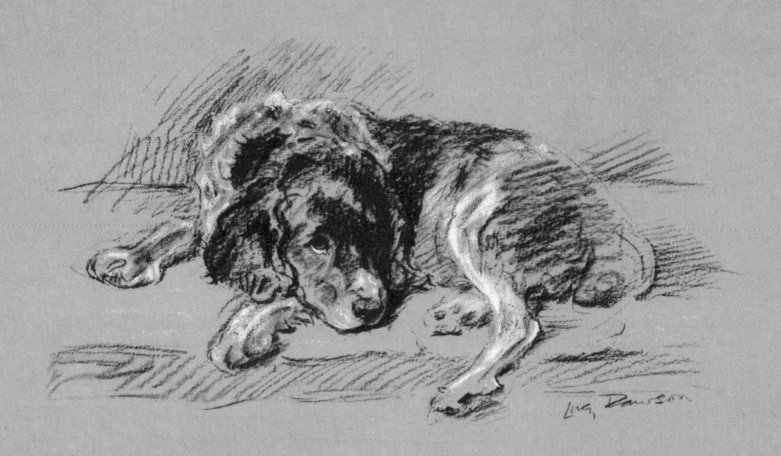

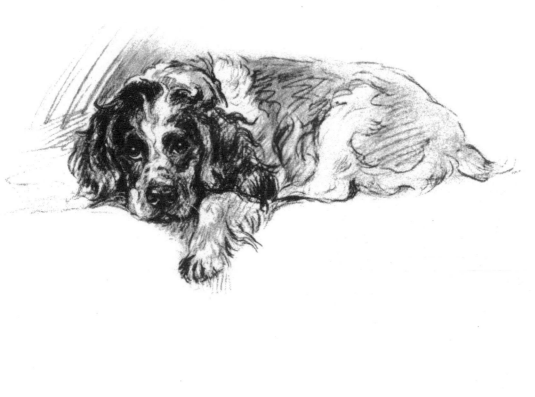

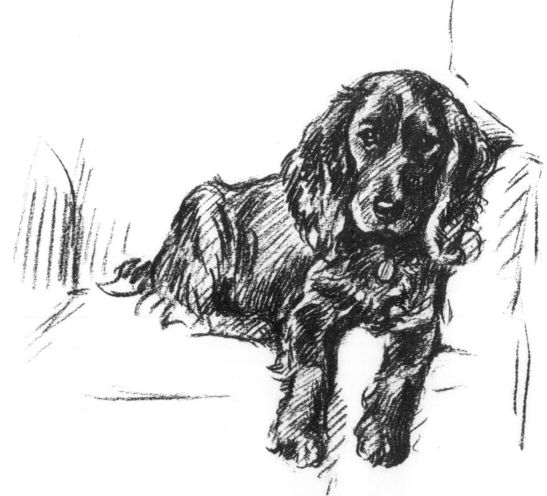

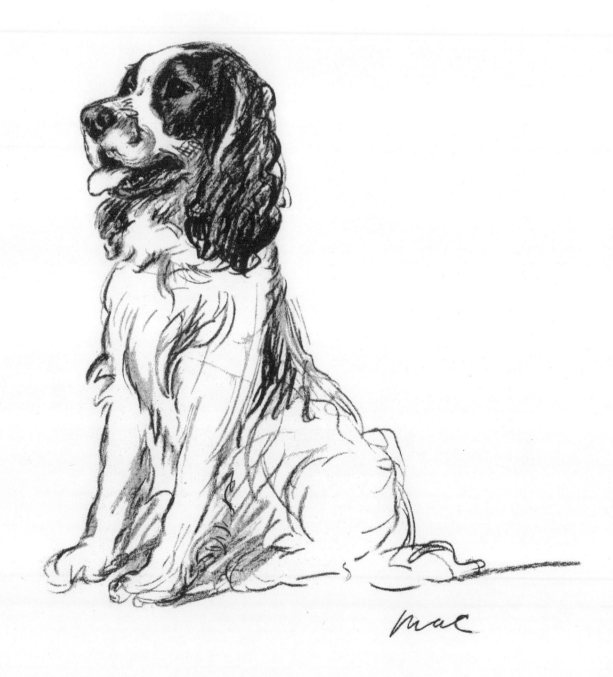

OONAGH

A wire-haired dachshund of some distinction who welcomes me most kindly. I should really have drawn her in a begging position as she seems to be able to sit up indefinitely, which always puzzles me when I look at her very long back.

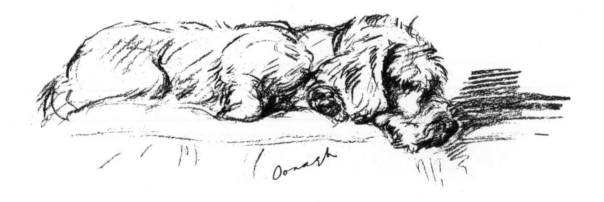

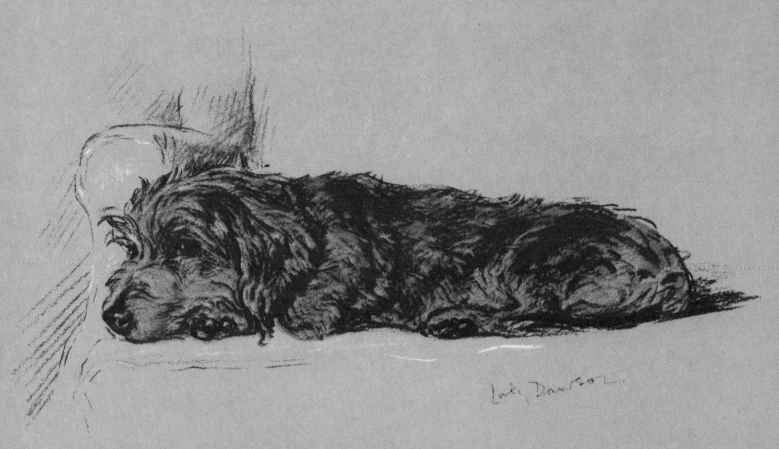

Wire haired Dachshund

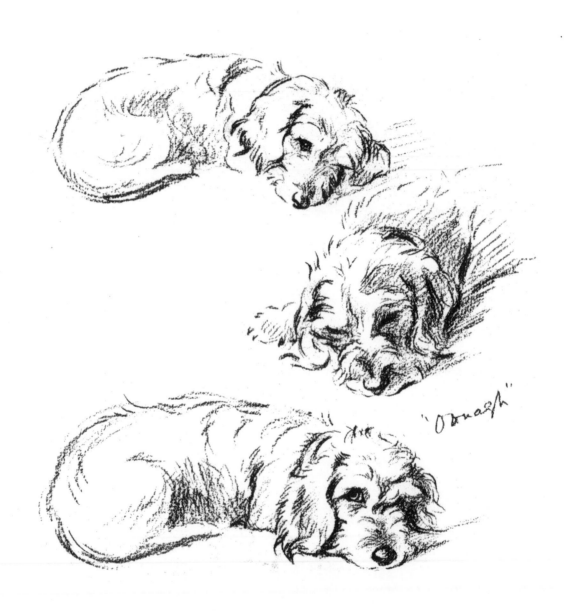

"Oonagh"

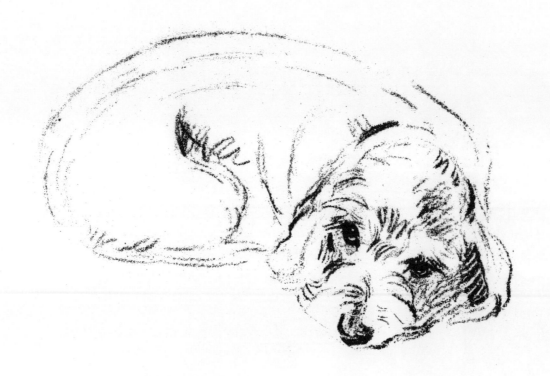

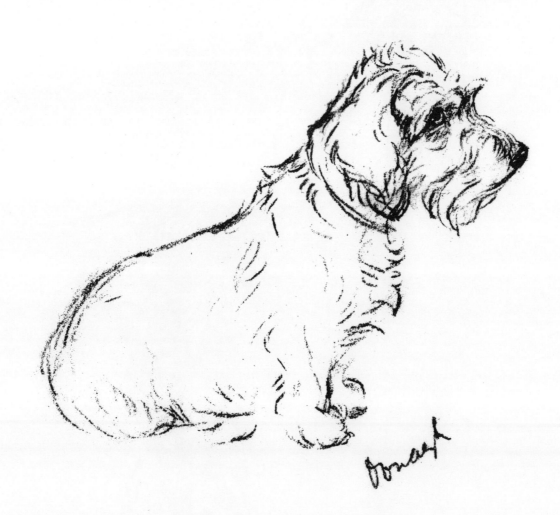

CREENAGH

Often I visit a kennel of little "Scotties," and their boisterous greeting never fails to take me out of myself when in low spirits. Almost they persuade me that I am their greatest friend—but biscuits can explain a lot. Janet and Creenagh are old friends of mine, and the industry and perseverance of their race are illustrated by the way in which they will beg for hours on end—to the very last biscuit. As professional models they demand a very high rate in biscuits per hour.

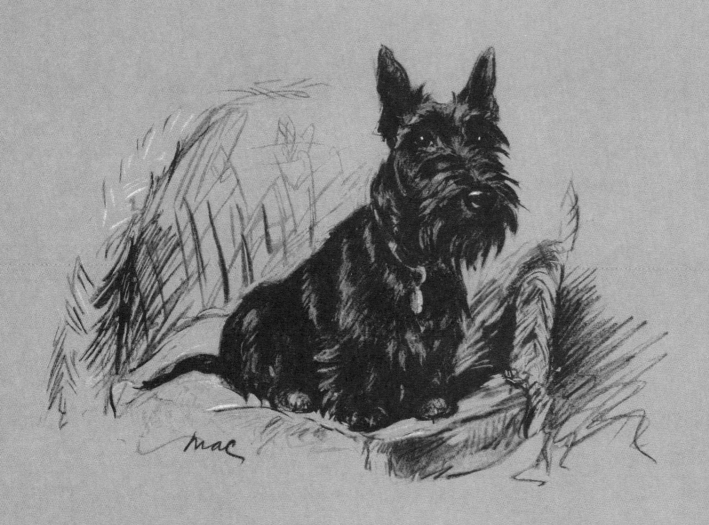

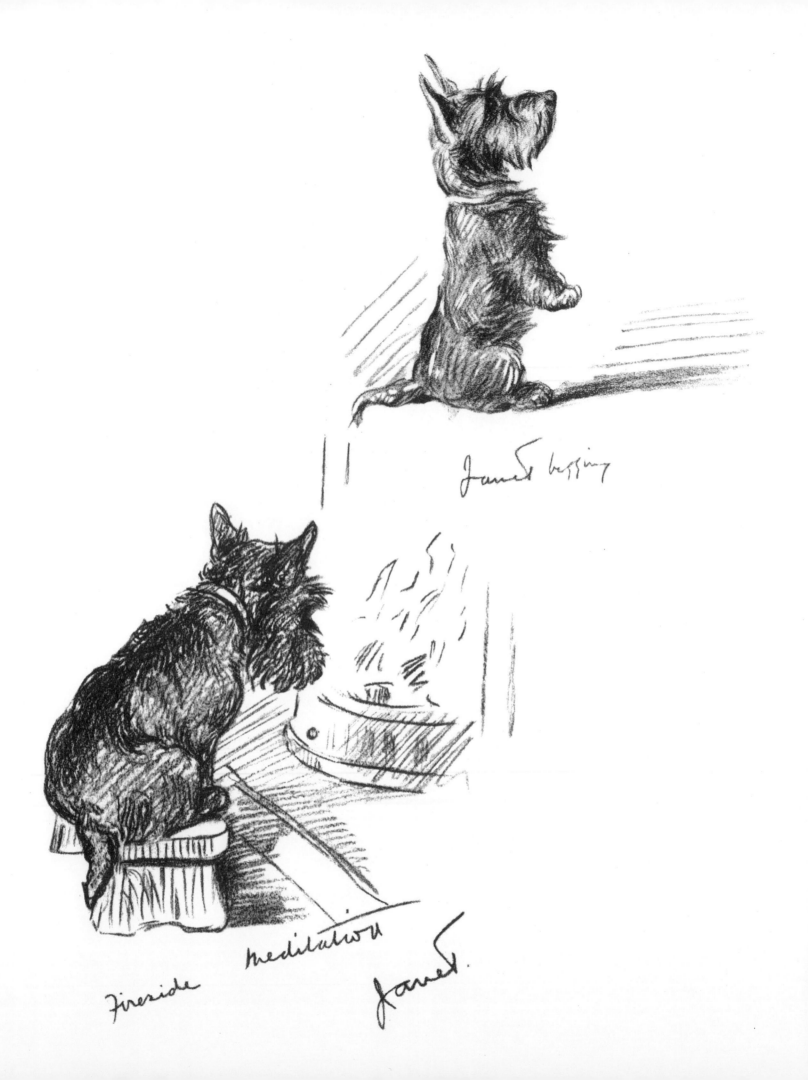

Fireside Meditation

My neighbours — seen from my window

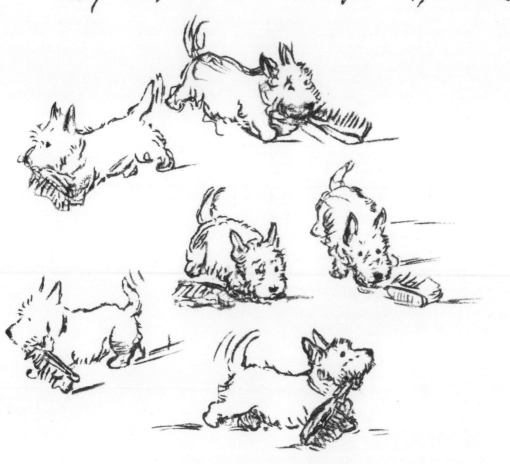

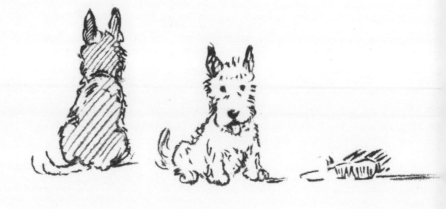

DEENA

Deena, whose home is in London, prefers to live in Cornwall. She is celebrated for her smile which she always effects when told she is naughty, so that her owners find it difficult to scold her. Certainly a broad smile on a sealyham is most disarming. In London she dislikes walking (on account of the pavements—I believe sealyhams' feet are often very tender), but in Cornwall she spends her time out of doors—hunting, if given a chance.

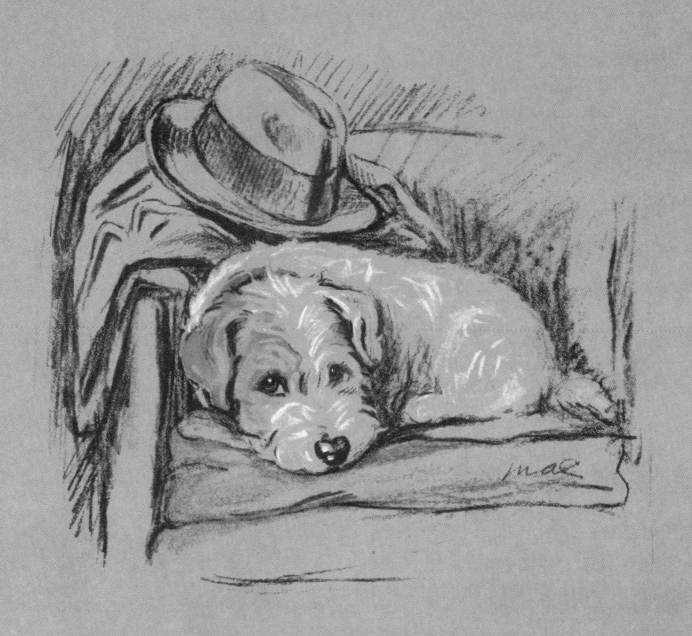

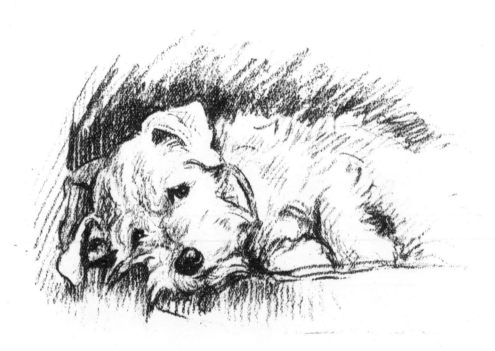

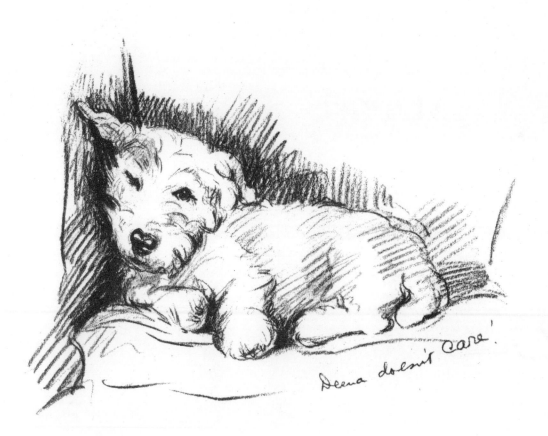

Deena doesn't care!

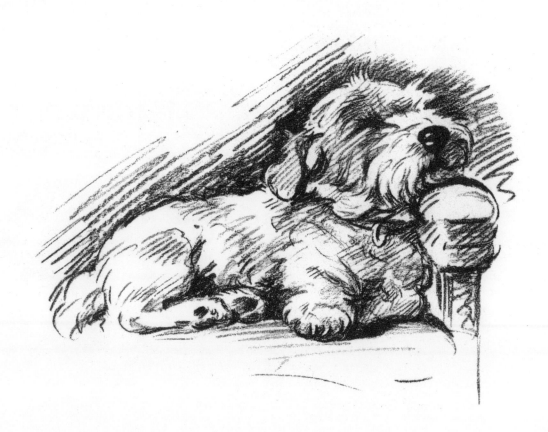

ALBERT

Albert is Deena's son, with all her characteristics—and just as lovable. We met when he was only a few weeks old at his home near the Albert Bridge—hence his name. He soon got to know (perhaps Deena told him) that if he kept changing his position whilst being a model he would be given a piece of biscuit to gain his attention. As his owner doesn't approve of such manner of feeding, our sittings often came to naught. Moreover, Albert was temperamental and being a model didn't always appeal to him.

The interval.

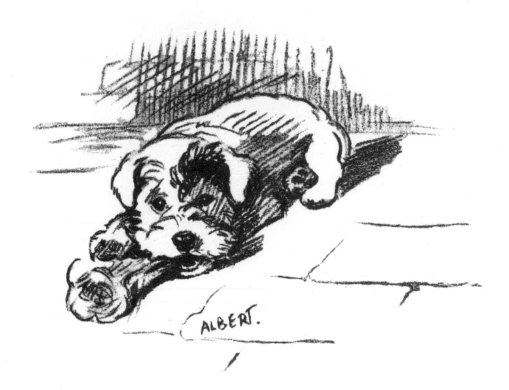

ALBERT.

Albert mac

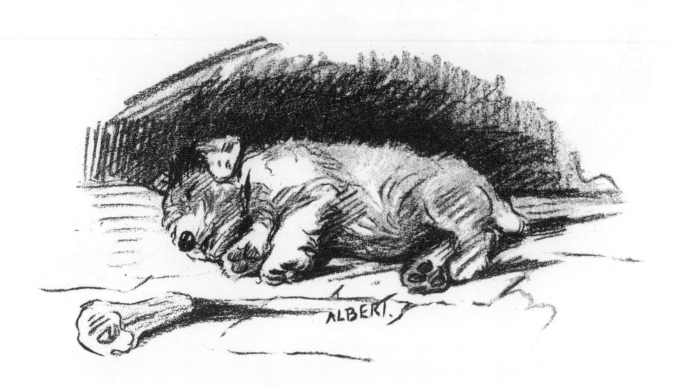

JOAN AND MINNIE

I thought Joan (the bulldog) would look very nice sitting up, but on being left to ourselves Joan decided otherwise and got under a chair for shelter. Every time I moved the chair Joan followed, so in desperation I left her there. Somehow I managed to get what you see on the opposite page. Minnie ignored me. They only sprang into life when their mistress returned.

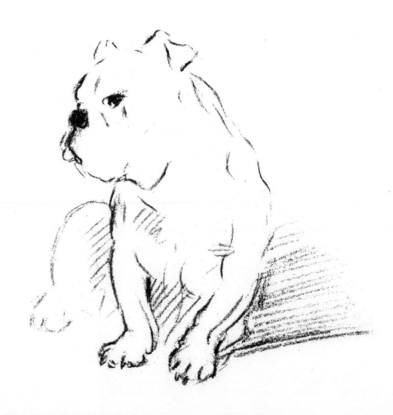

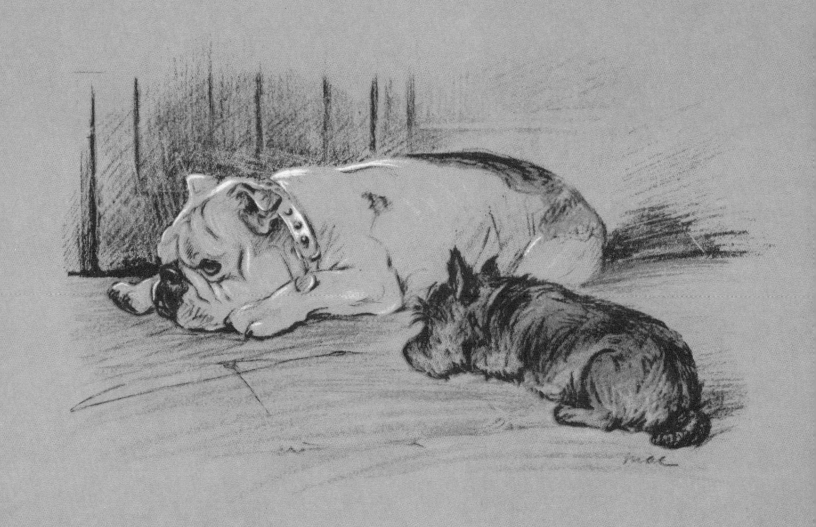

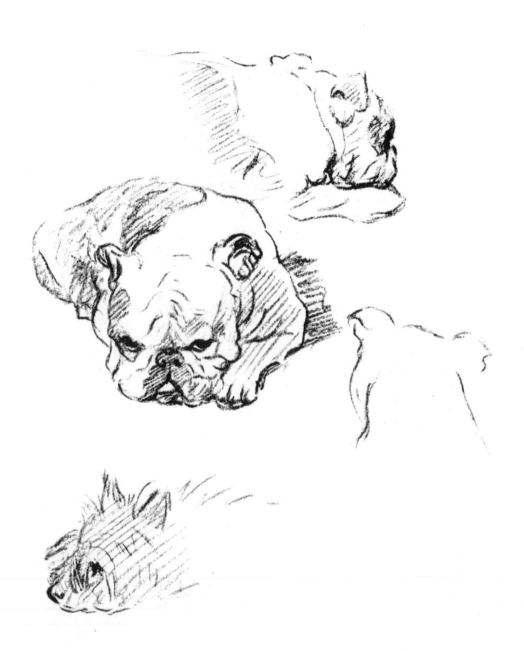

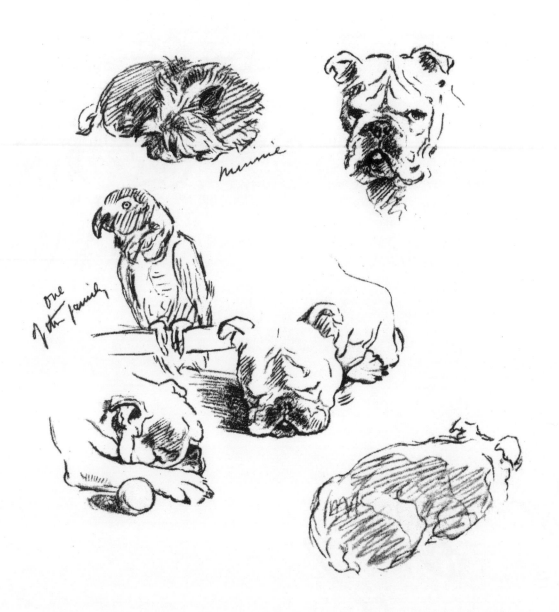

BORIS

Several times I had watched Boris walking with his mistress, and one day I took my courage in both hands and asked permission to draw him. Here he is, and a very noble fellow I found him. Wanda, whom you see in black-and-white, is strangely musical, so her mistress kindly played the piano during the sitting and chose some favorite music. Wanda likes classical music and dislikes anything of a jazzy nature. She will lie quietly for hours listening to music that she enjoys.

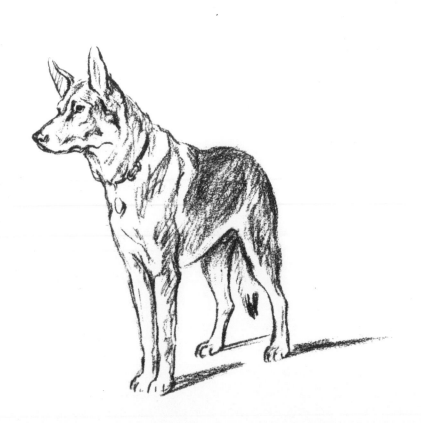

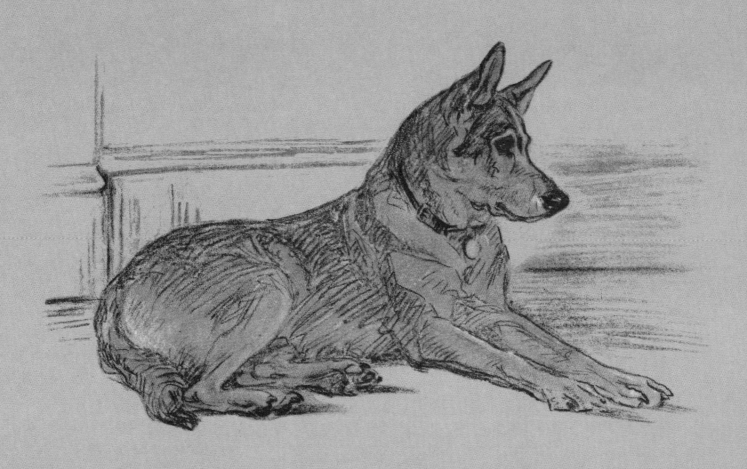

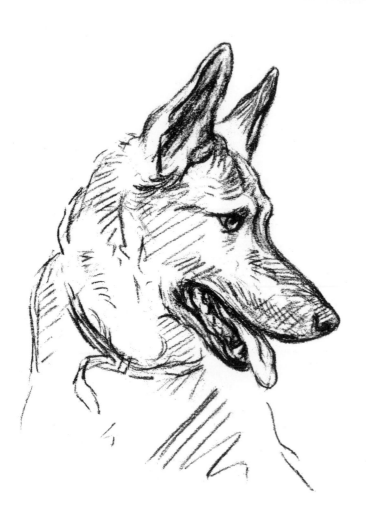

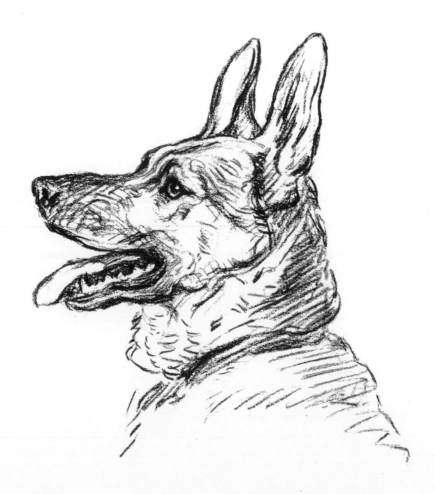

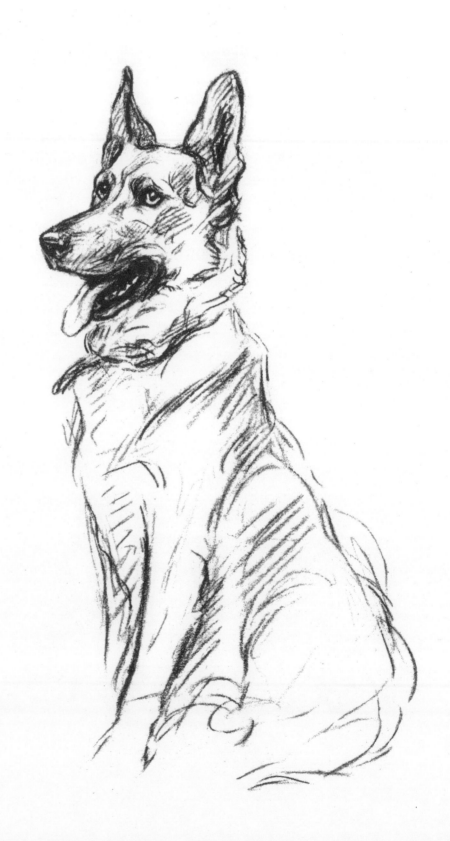

PATCH

This young woman—pretty and mild-eyed—was my visitor in the country for five weeks last spring. Generally she is very well behaved, so three days' absence rabbit-hunting was more than we expected and decidedly disconcerting. A favorite trick of hers is to stalk some unwary dog and suddenly and noiselessly pounce upon him—just as a joke. All dogs are perfect little gentlemen and take it very well, but it wasn't quite such a joke the day she selected one of her own sex!

As a companion and mother Patch has few equals, and we must make some allowances for our friends.

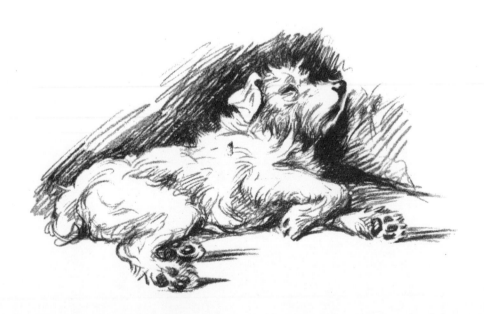

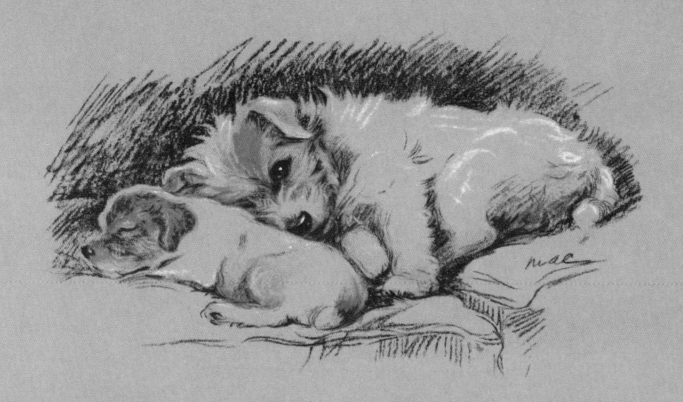

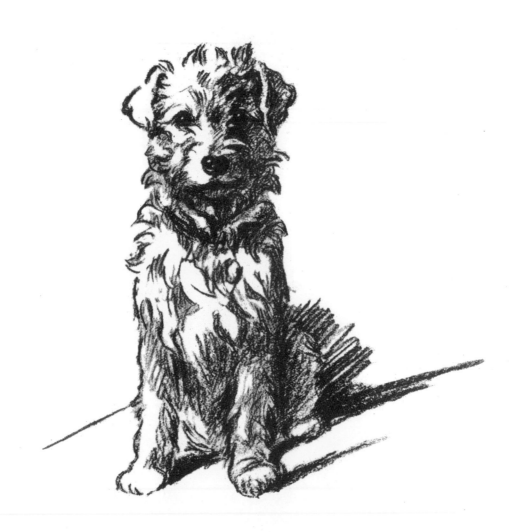

The next day —
or sleeping it "off"

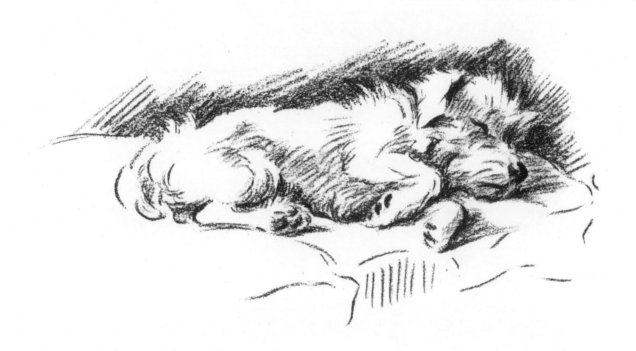

"Patch"
after the 3 days
Rabbit-hunt

GEORGE

A great little dog of no small importance in his home. He conscientiously guards his mistress and everything belonging to her—he would give his little life if necessary.

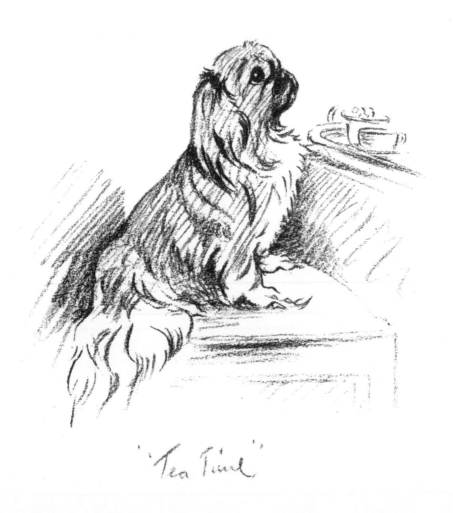

"Tea Time"

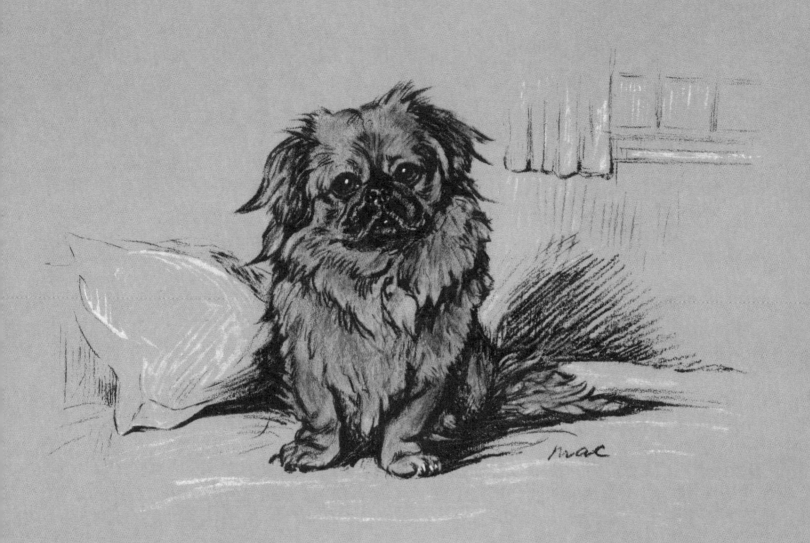

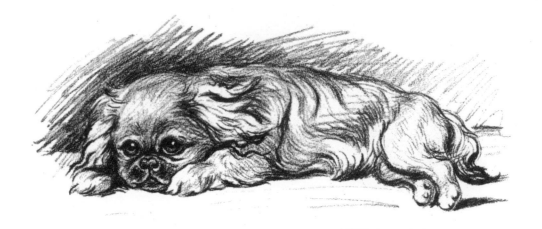

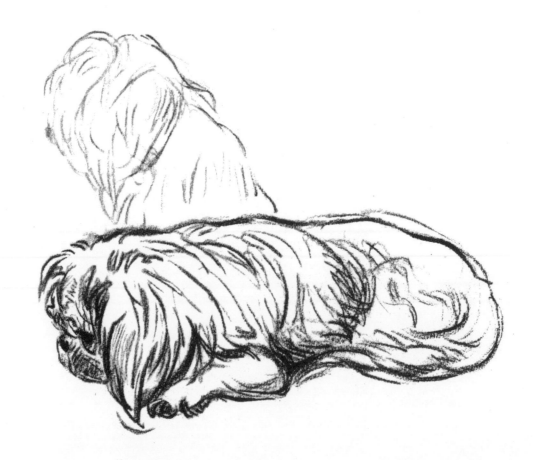

RED PRINCE OF WU SUNG

Now here is a super show dog. I had to have the help of the owner, well known as a chow breeder, to be sure that I got his points right. He has won many prizes at the best shows and so has his daughter Lalli. They live in a kennel in company with the most charming chows of all ages. Red Prince and Lalli are perfectly sweet in disposition, and delightful companions.

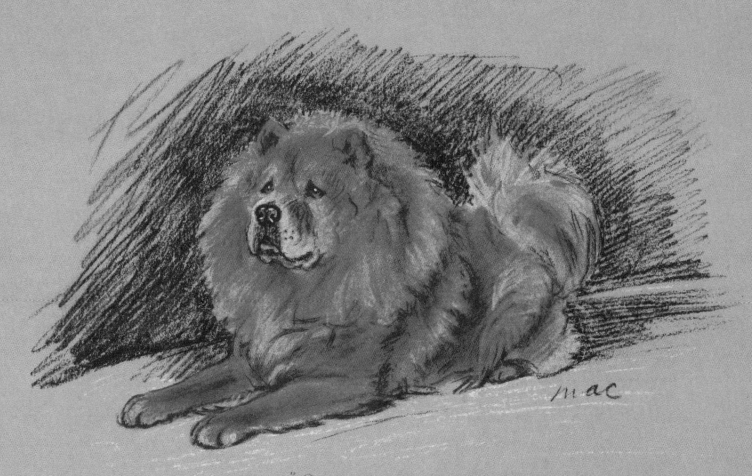

"Bruce of WU-SUNG"

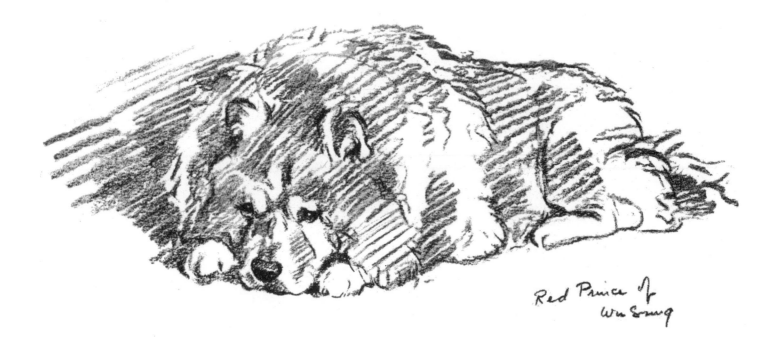

Red Prince of
Wu Sung

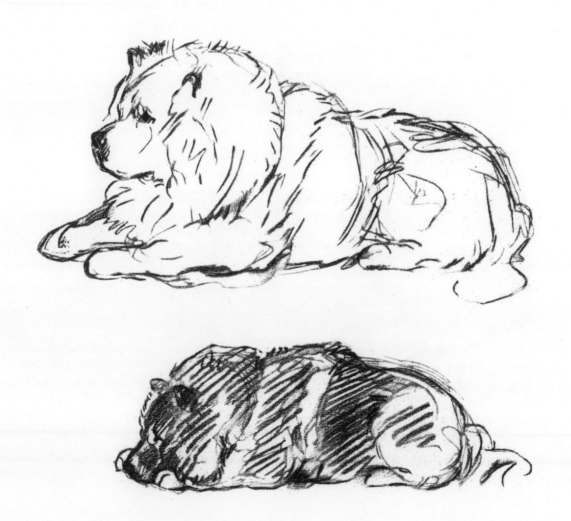

BERBAY'S LAD AND THE SIAMESE CAT

A cat-and-dog life—but not on traditional lines. A boisterous fellow, Laddie, from whom I get a most enthusiastic greeting—but his cat friend politely ignores me. I am told she knows everything that is said to her for "Siamese cats are different" and more intelligent than the ordinary cat. That means they must know a lot because our own cats are certainly not stupid.

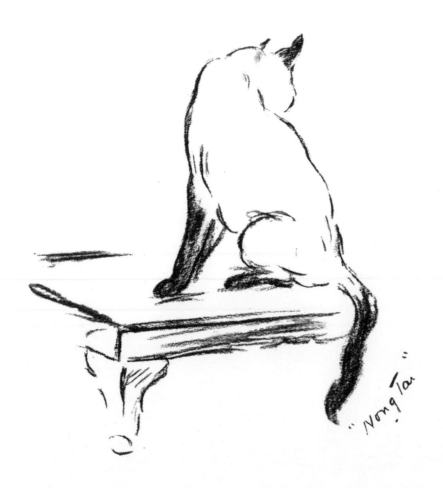

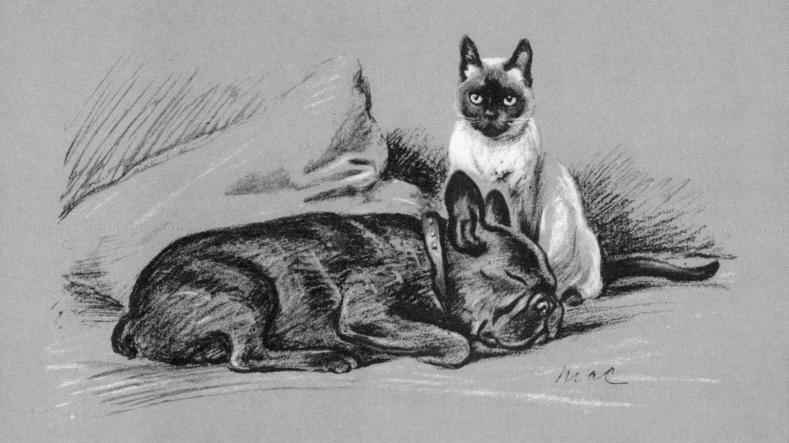

"Berbay's Lad"

"LADDIE"

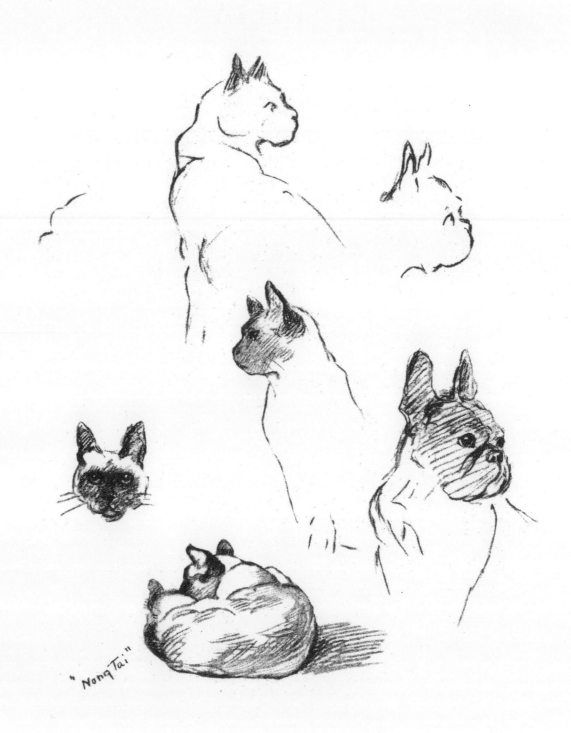

"NongTai"

BILLY

Of aristocratic breed, Billy was quite young when the sketch was made—very beautiful by nature and beautiful to look at. Most intelligent and definitely a "one-man dog." He suffers fools gladly but he's very difficult to get to know.

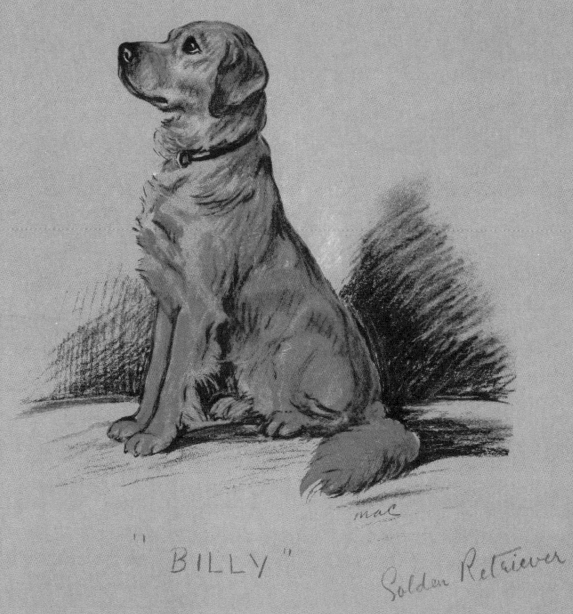

" BILLY "

Golden Retriever

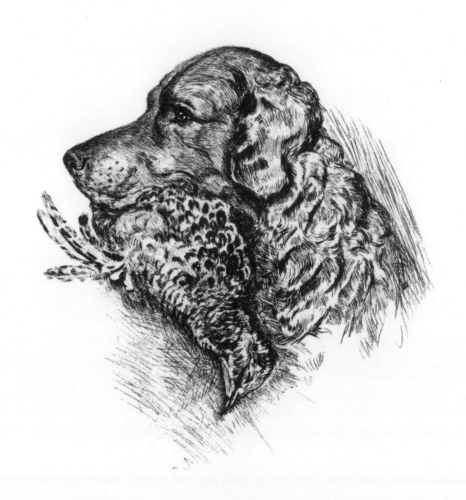

MIKE

Now Mike is no show dog, but he is very proud of the fact that he is directly descended from King Edward VII's dog Caesar. Full of character and extremely intelligent, I've drawn him almost since he was born, and I hope he has a long, happy life in front of him.

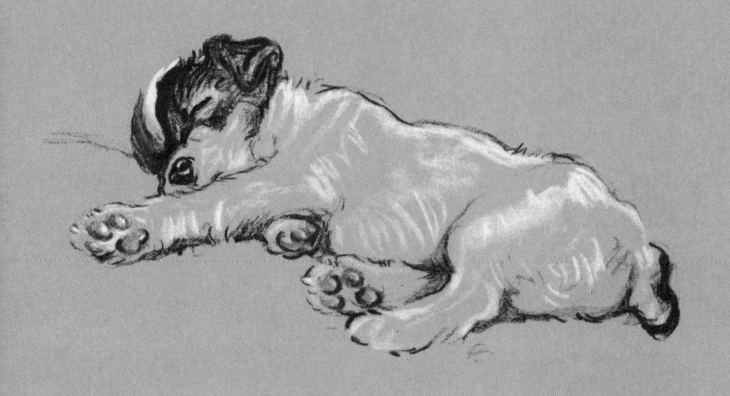
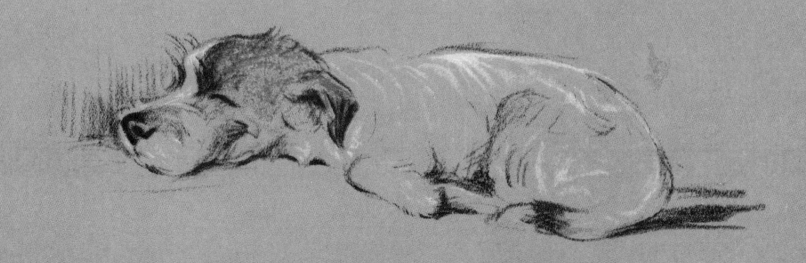

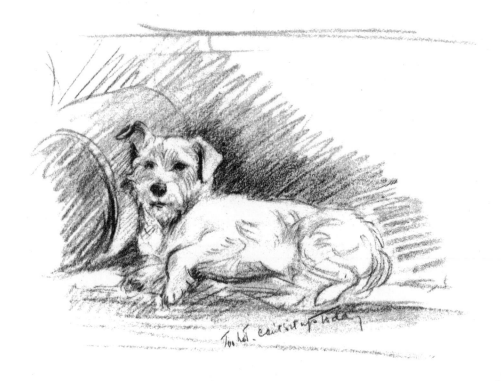

Too hot. Cairn asleep on hearth

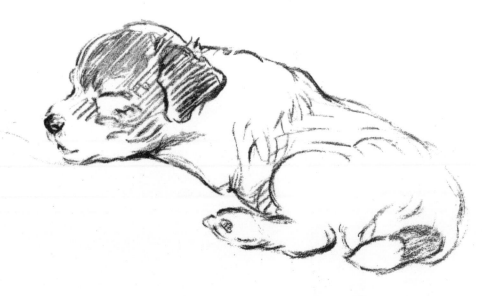

Mike

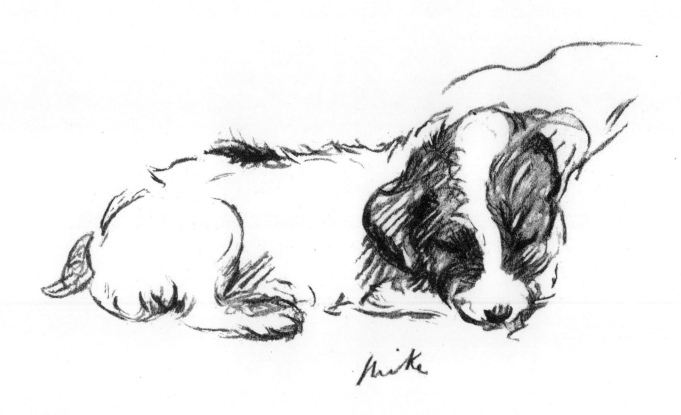

CAESAR

One of the few dogs who is content to come along to the studio without his owner. He spends the day with me quite happily although we are only slightly acquainted. A jolly little companion. I covet so many of these models, but my own dog sees to it that no others share his home. In fact he rather bullies me.

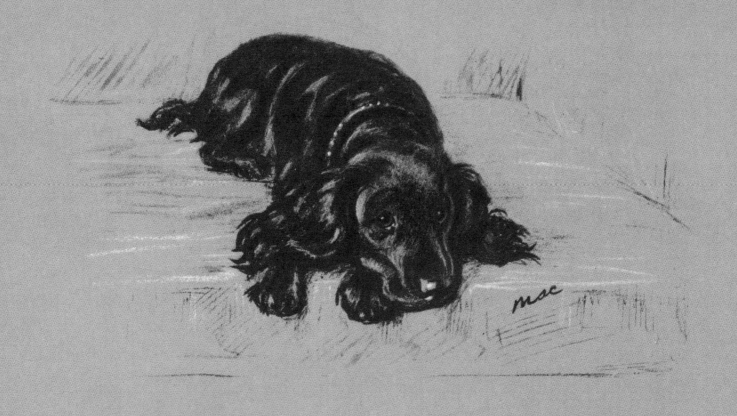

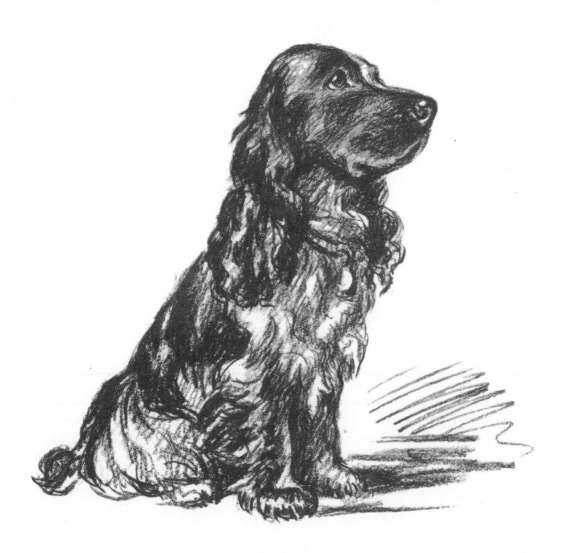

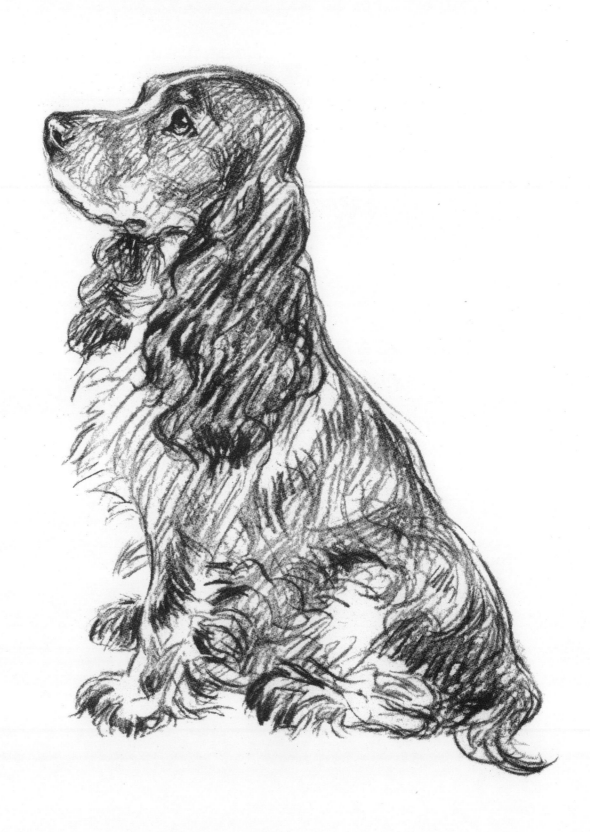

MALICK AND WOODIE

An occasional biscuit kept the attention of this happy pair. When weary of tidbits, they went to sleep, which suited me very well. When awake they can be quite lively, as anyone who knows this breed will appreciate.

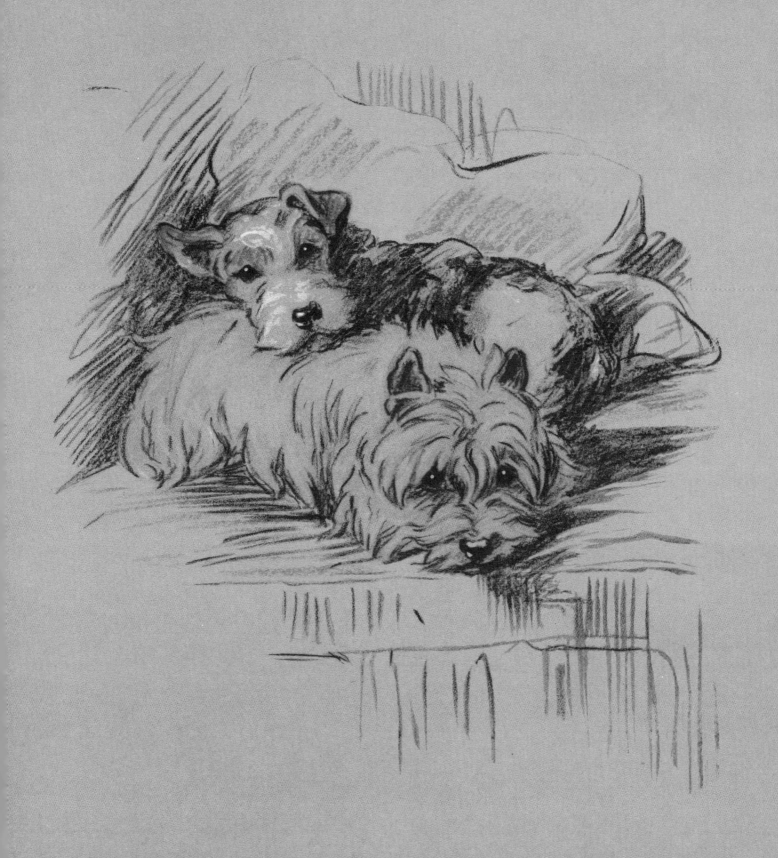

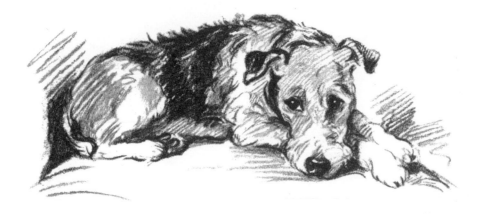

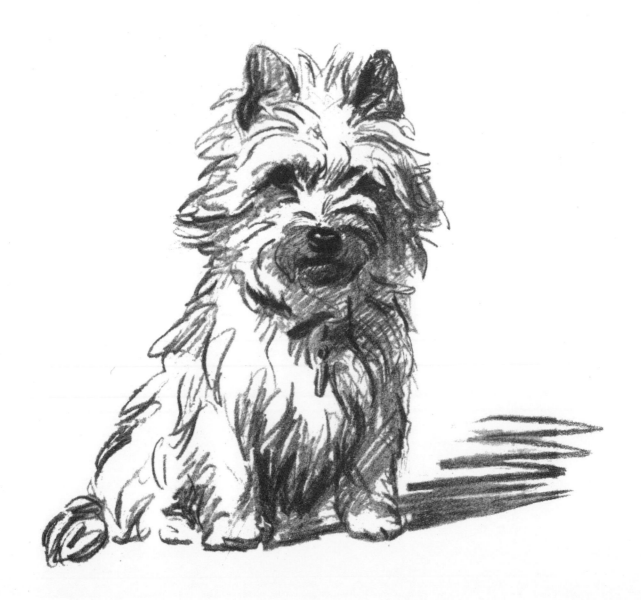

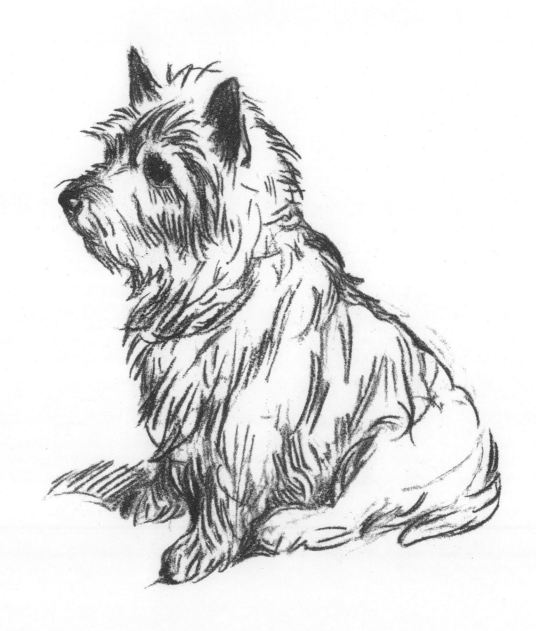

TRIG

Trig is a very affectionate soul and nearly eats me up with pleasure when I go and see him. Always full of fun, and a good, if not easy, subject to sketch. He did find the chair slippery, but he knew he must not get down. You can see that look in his expression.

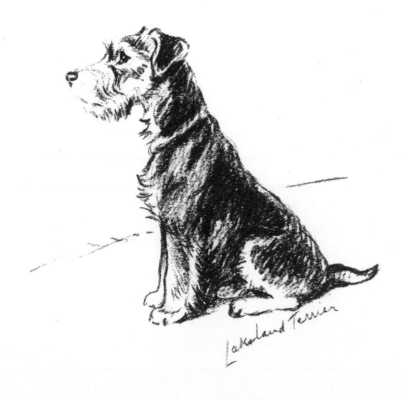

Lakeland Terrier

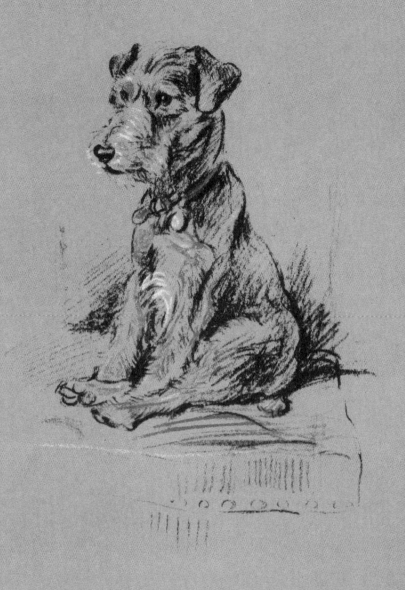

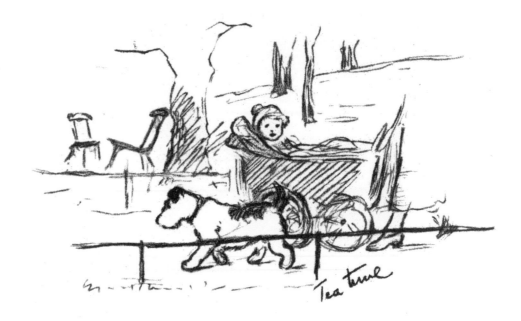

Tea time

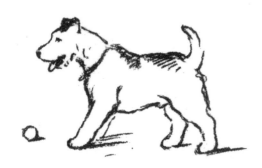

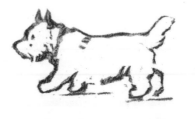

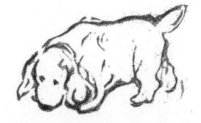

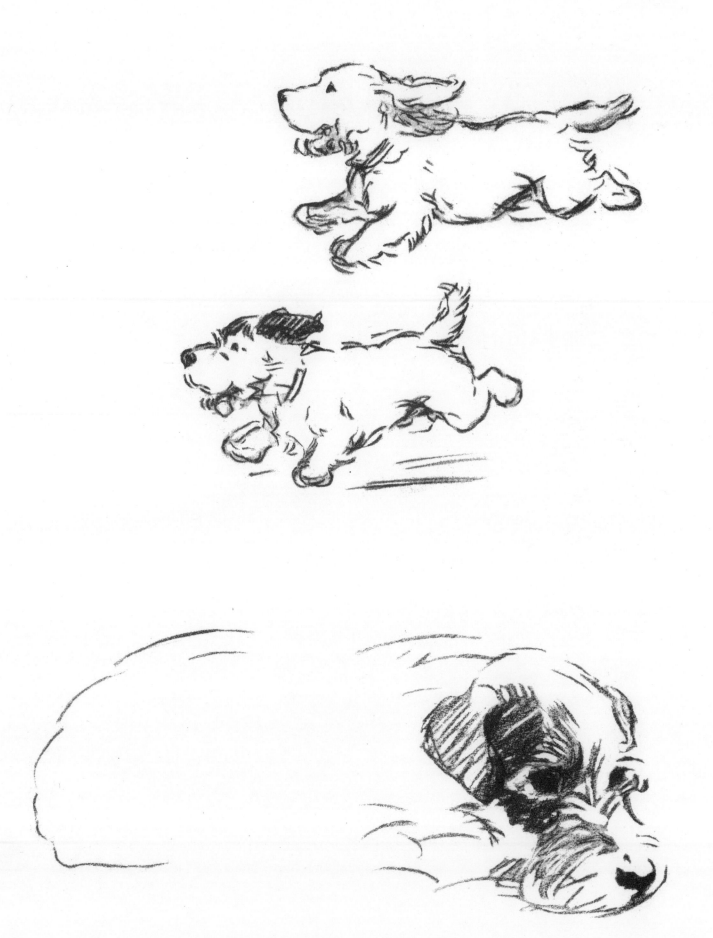

PATRICK

Patrick lived to a ripe old age. He had a lovely home at Thames Ditton, and I very much regret I was unable to get more sketches of him before he died. He was a wonderful model, and his constant companion was a handsome dalmatian.

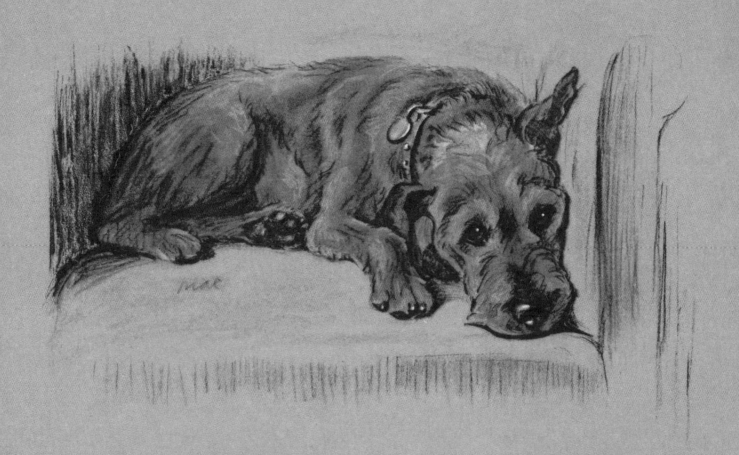

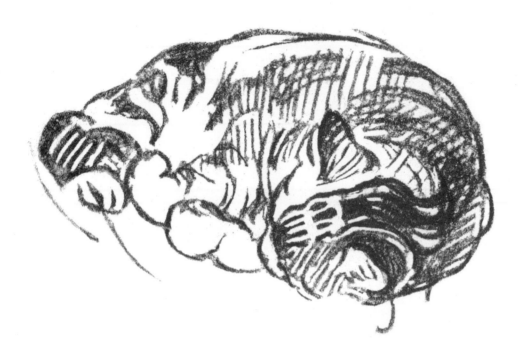

At Random

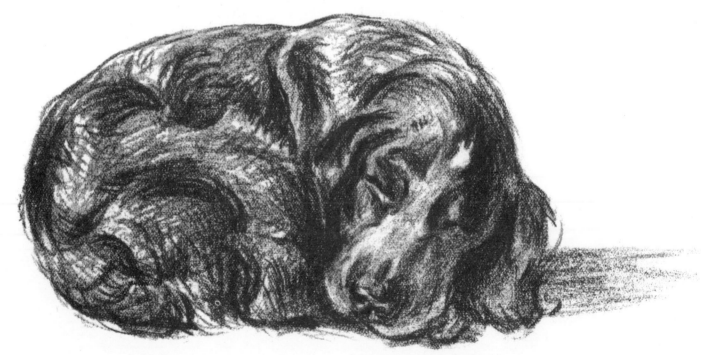

"Lucky Star" 1930

Still more "at Random"

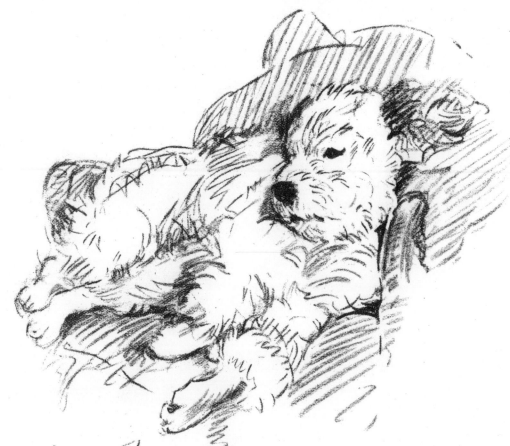

Algerian Sheep dog

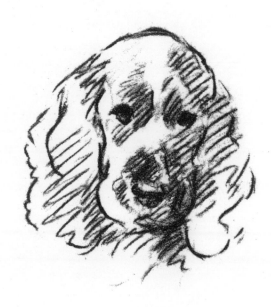

ABOUT THE AUTHOR

LUCY DAWSON (1870–1954) was a British illustrator best known for her paintings and etchings of sporting dogs and other breeds. She also created art for playing cards, cigarette cards, and numerous postcard series. She accepted commissions by individuals, most notably the Royal Family. She painted the Queen Mother's favorite corgi, Dookie, whose portrait was later reproduced as a Christmas card. She published several dog-related titles, including *Dogs As I See Them* (1936), *Dogs Rough and Smooth* (1937), *The Runaways* (1938), and *Lucy Dawson's Dog Book* (1939).

ABOUT ANN PATCHETT

ANN PATCHETT is the author of six novels and three books of nonfiction. She has won many prizes for her work, including Britain's Orange Prize, the PEN/Faulkner Award, and the Book Sense Book of the Year Award. Her work has been translated into more than thirty languages. She lives in Nashville, Tennessee, where she is the co-owner of Parnassus Books. Her dog Sparky can often be found working in the store.

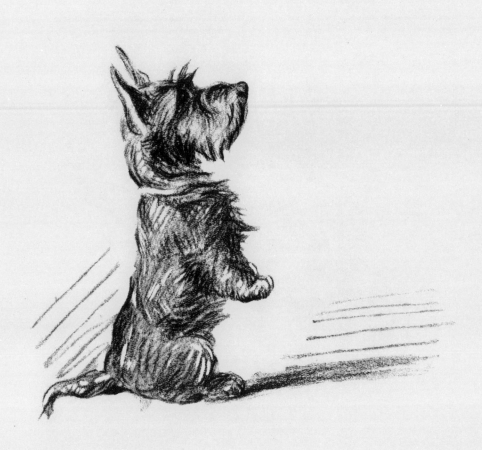

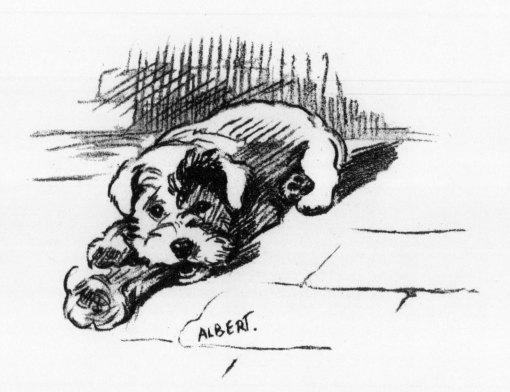

ALBERT.